Good Karma Adult Coloring Book

Charity means giving something to those in need without expectation or wanting something back but in this case you get good karma points and an awesome coloring book.

Proceeds from this book are donated to the Ontario Society for the Prevention of Cruelty to Animals (Ontario SPCA). Through its province-wide network of close to 50 Communities, the Ontario SPCA is one of the largest, most responsive animal welfare organizations in the Canada, providing care and shelter for tens of thousands of animals every year.

As a huge animal lover and animal adoption advocate, I am all about helping lovable shelter pets find homes.

In 2015 I started to work with Ontario SPCA Stormont, Dundas & Glengarry Branch, an amazing local shelter, as a volunteer photographer. I believe a great-looking photo is one of the ways these animals attract the attention of potential pet parents, and making sure each one has a terrific photo is always my goal.

It isn't always an easy or simple task – many of the animals are stressed with fear and pent up energy as a result of shelter life, some have been neglected or abused, others have limited social skills. Aesthetics can be challenging, as can lighting. But most often, all the animals need is a little time – time to release some energy, time to soak up some sun or stretch their legs, or time to get comfortable with me.

The rewards are immeasurable, the pets get the attention and exposure they need, and an improved chance of finding a forever home.

The animals featured in this book were all photographed while they were waiting to be adopted.

If you are looking for a best friend, please consider adoption for your next pet. There are SO many great animals *just waiting for a forever home.*

Yours truly,
Beth Lacelle Alexander
Pet Photographer

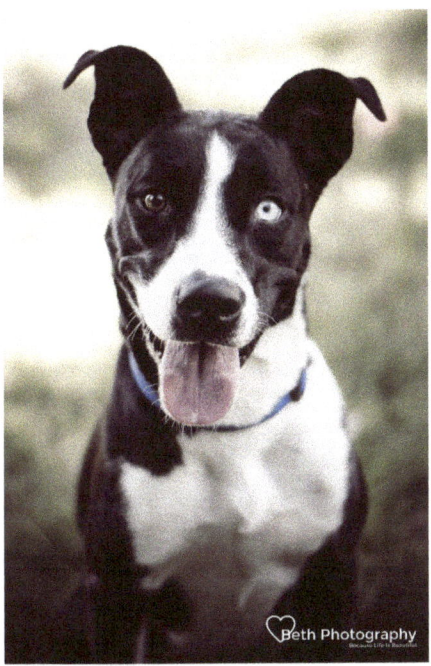

Because Life Is Beautiful
www.beth-photography.com

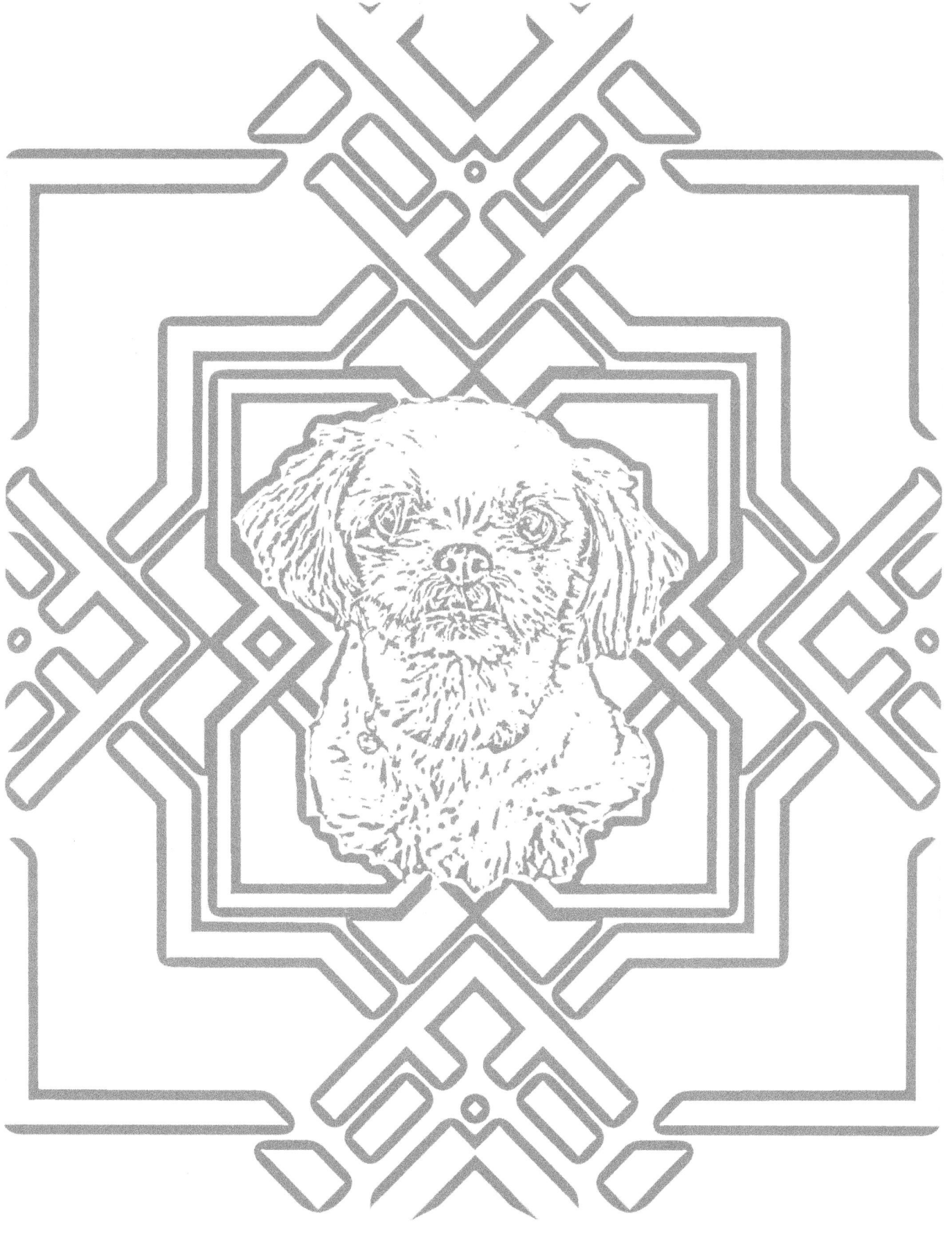

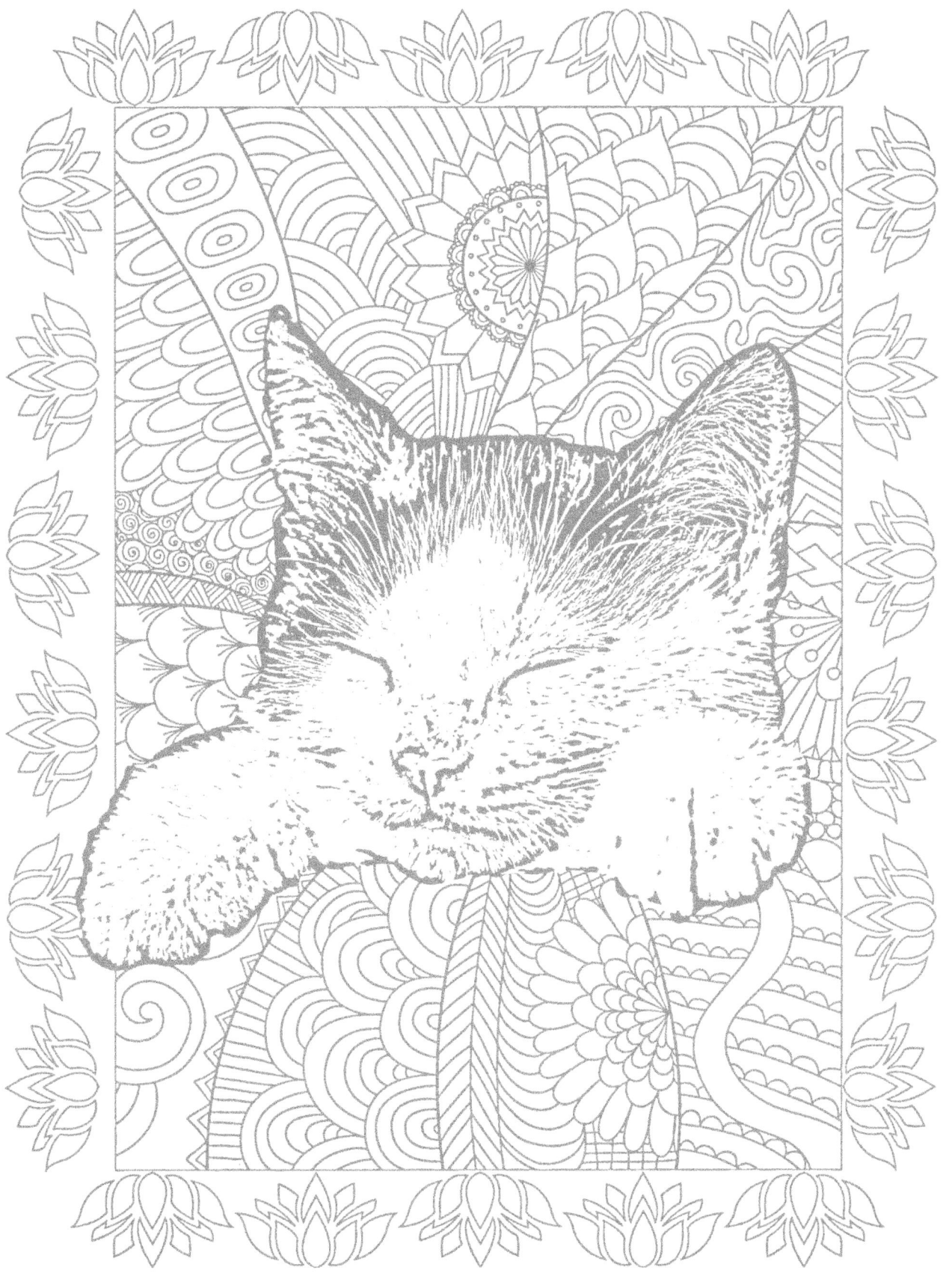

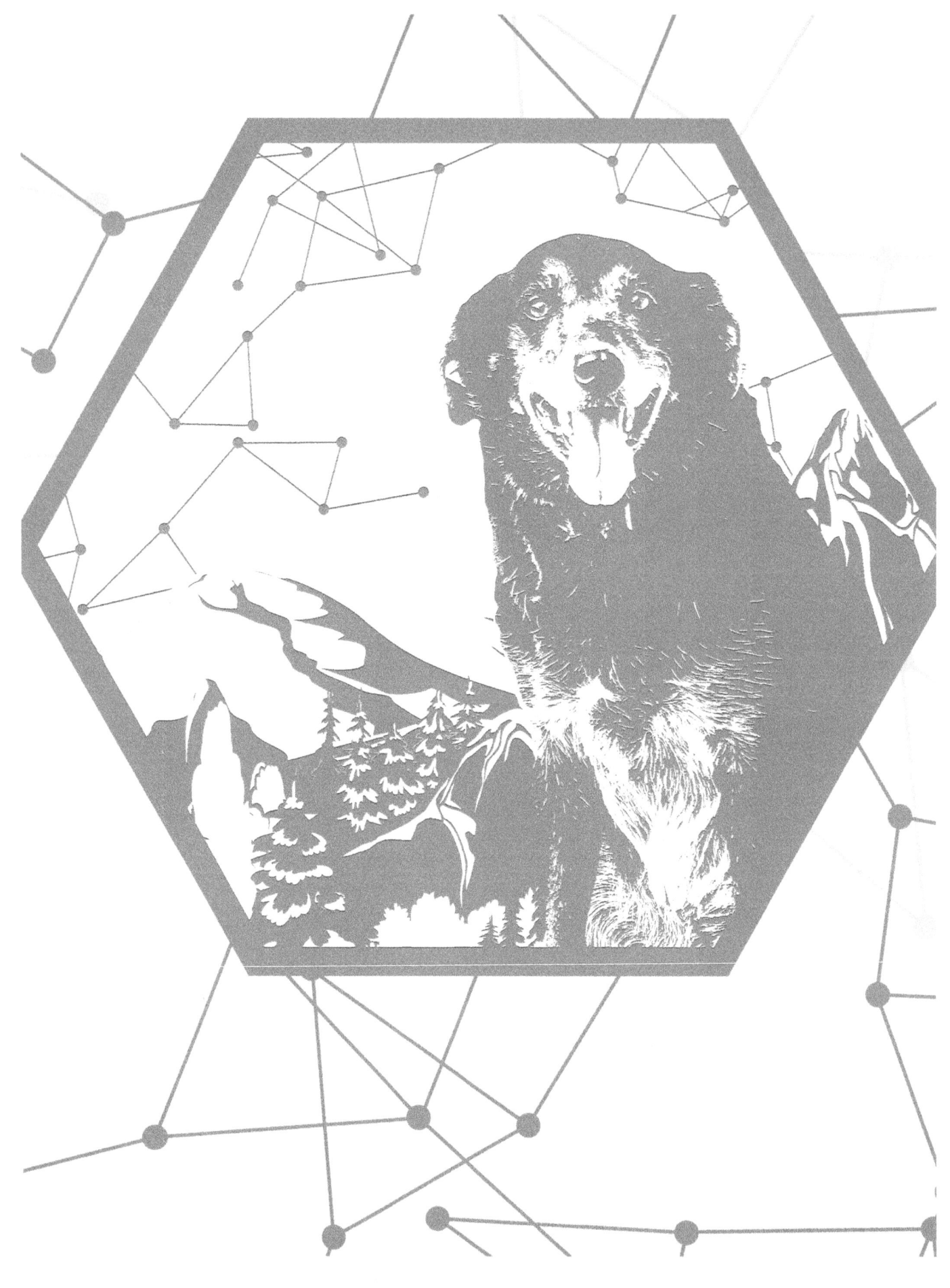

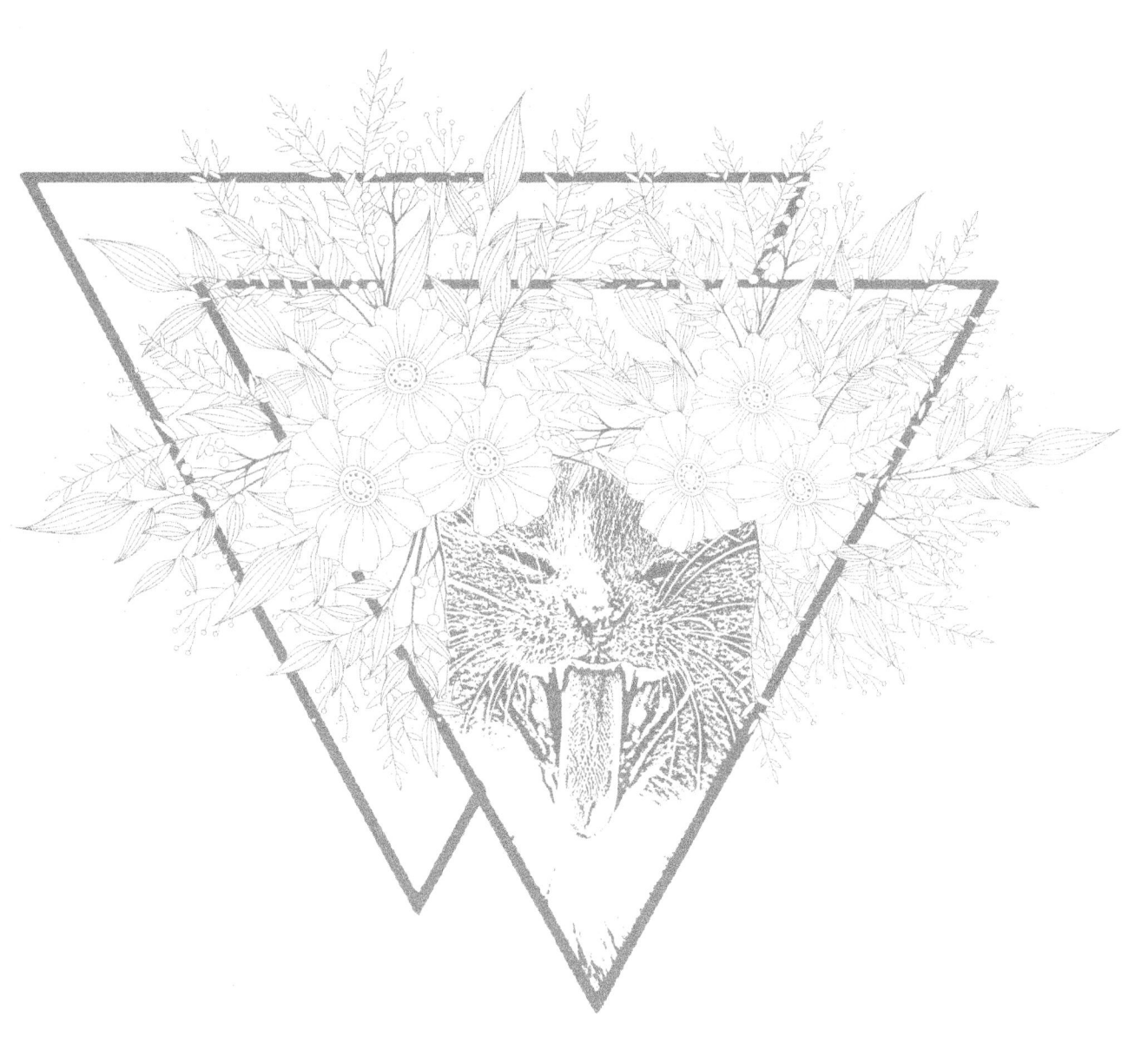

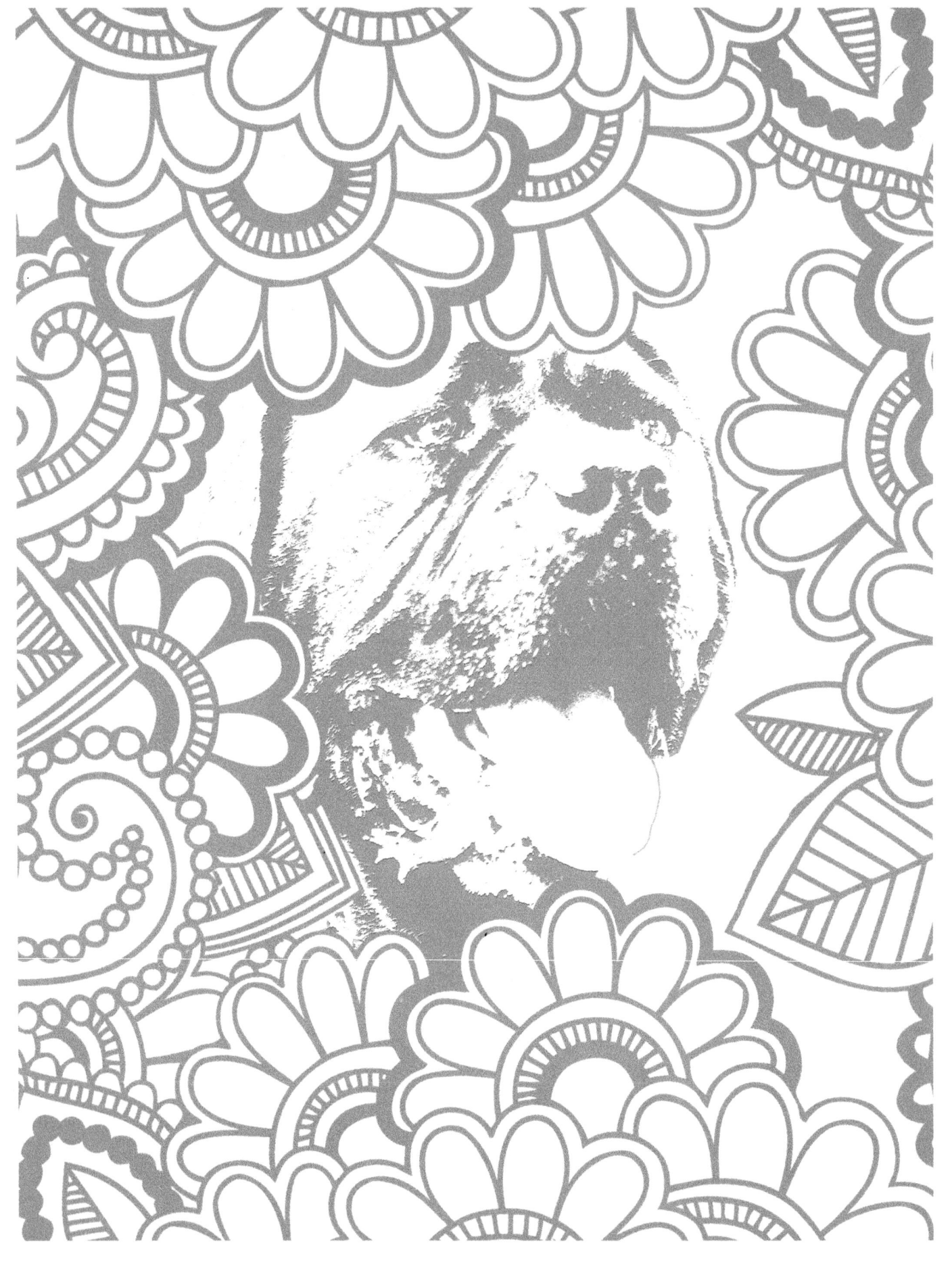

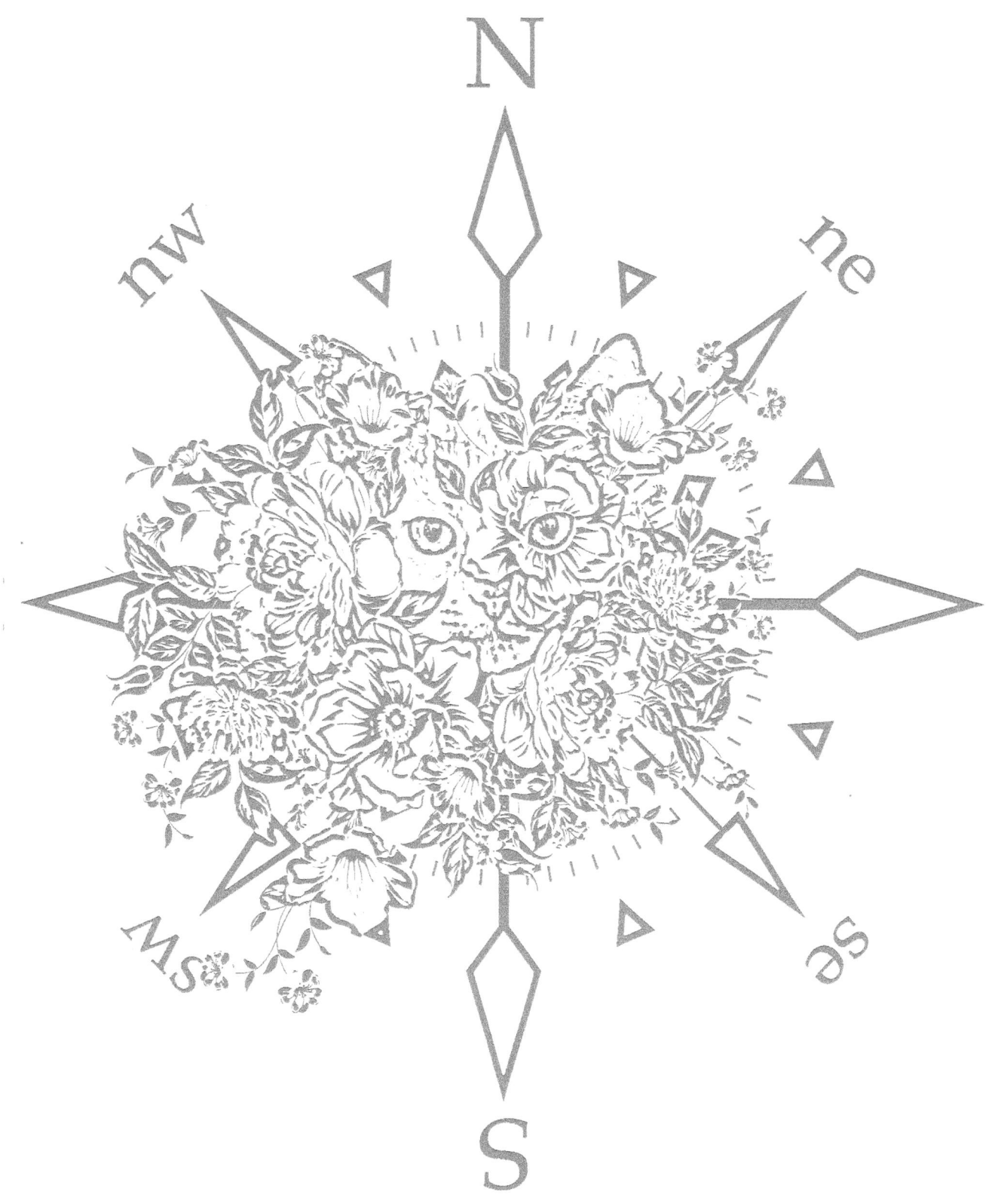

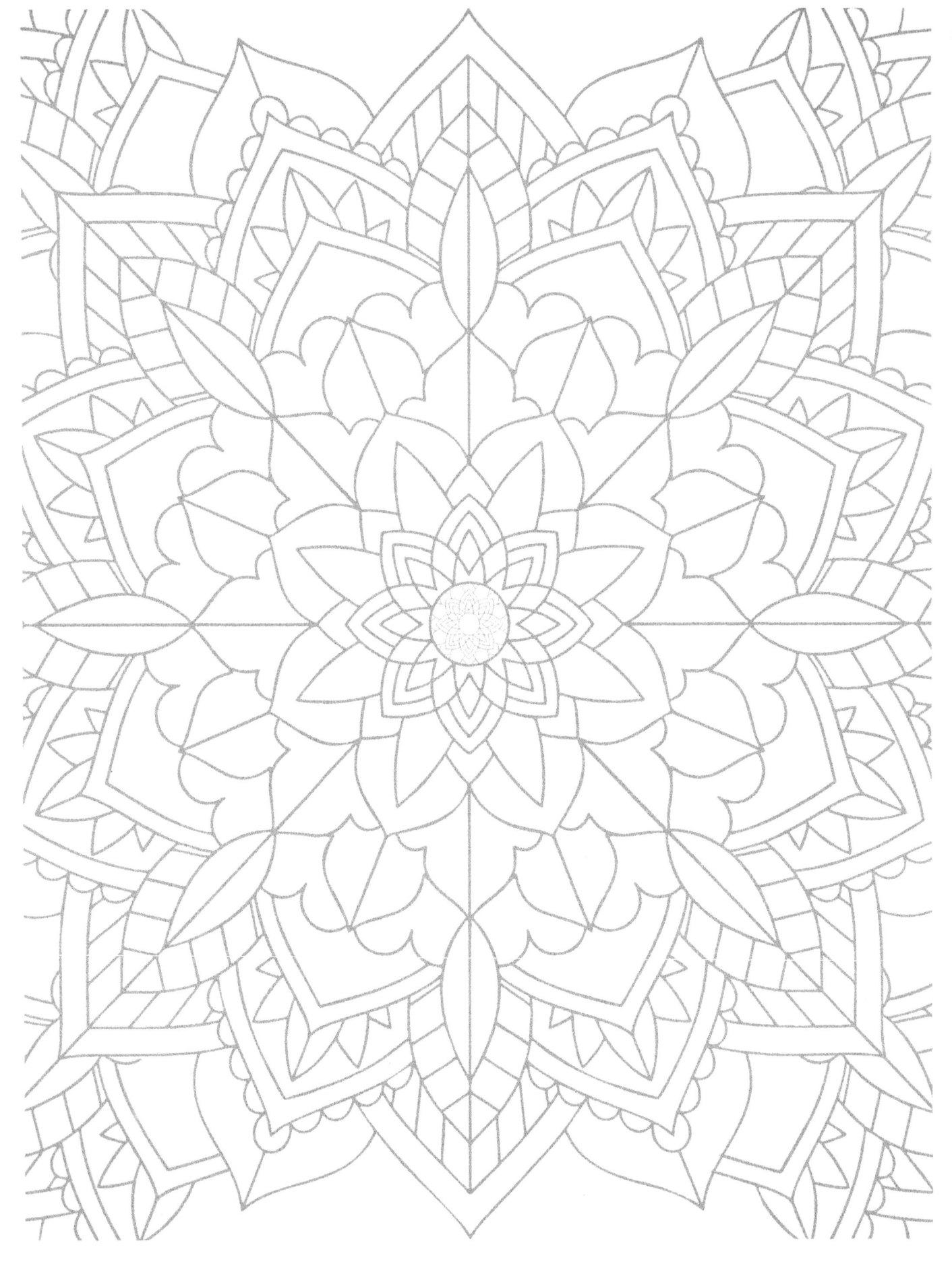

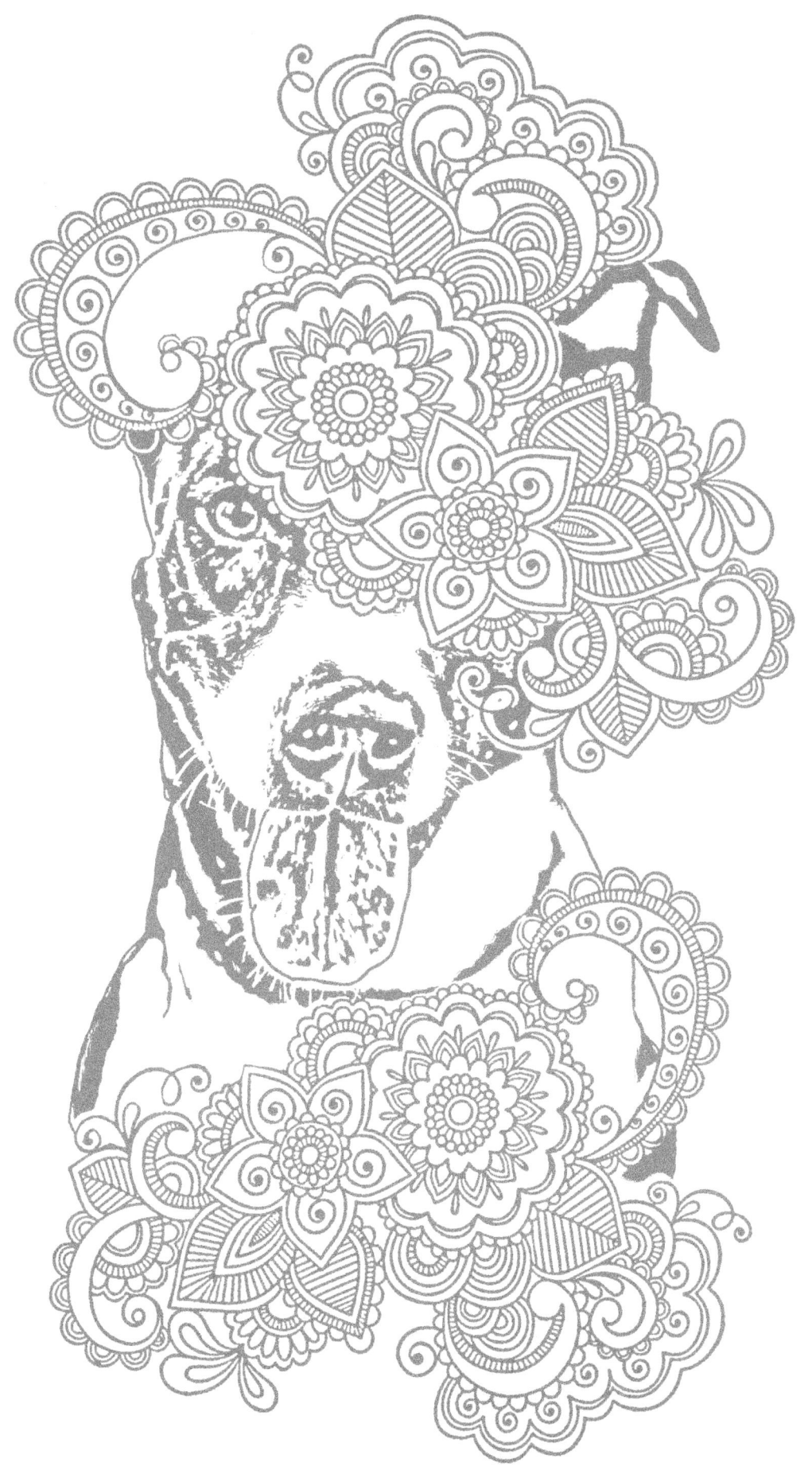

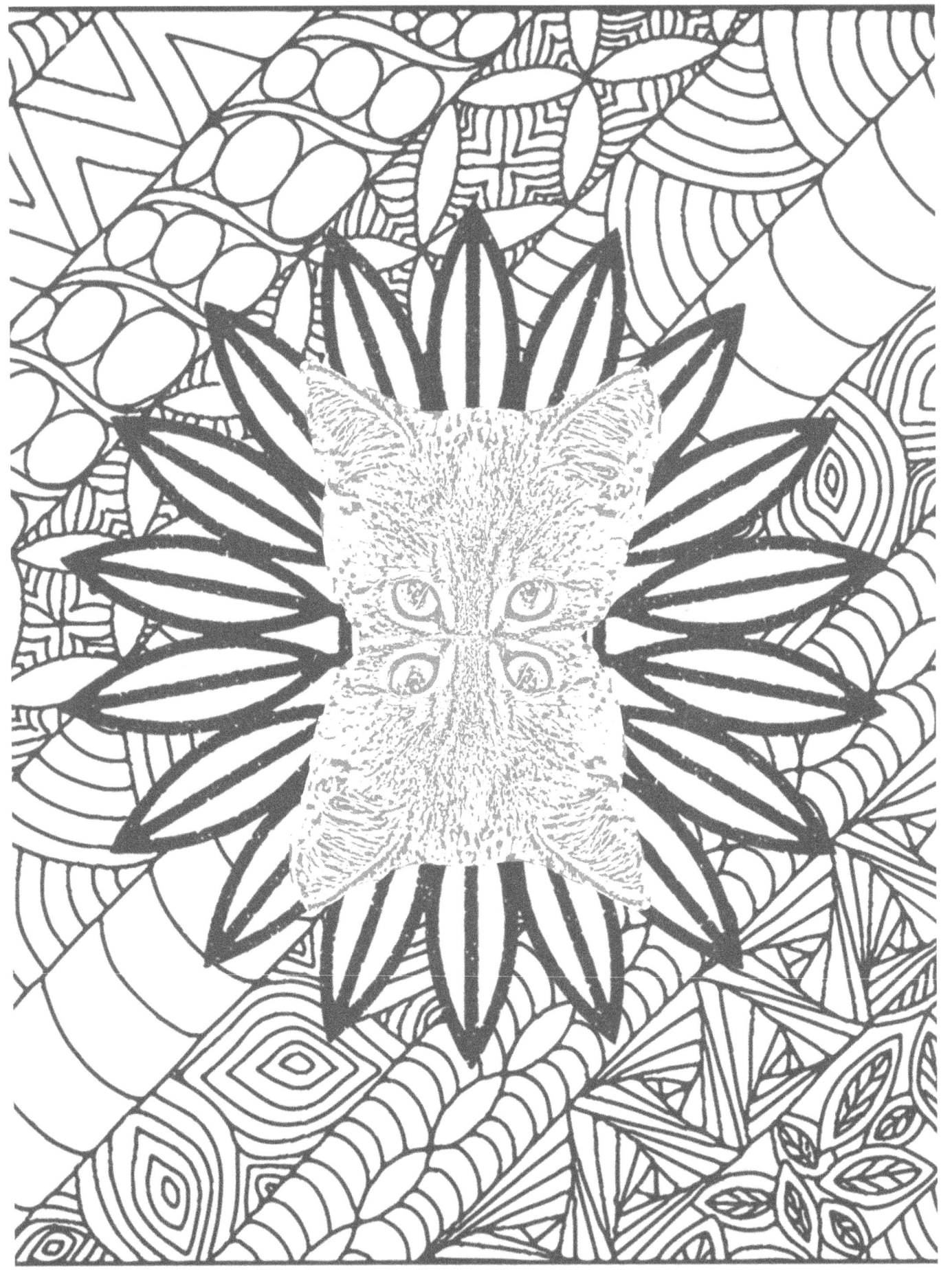

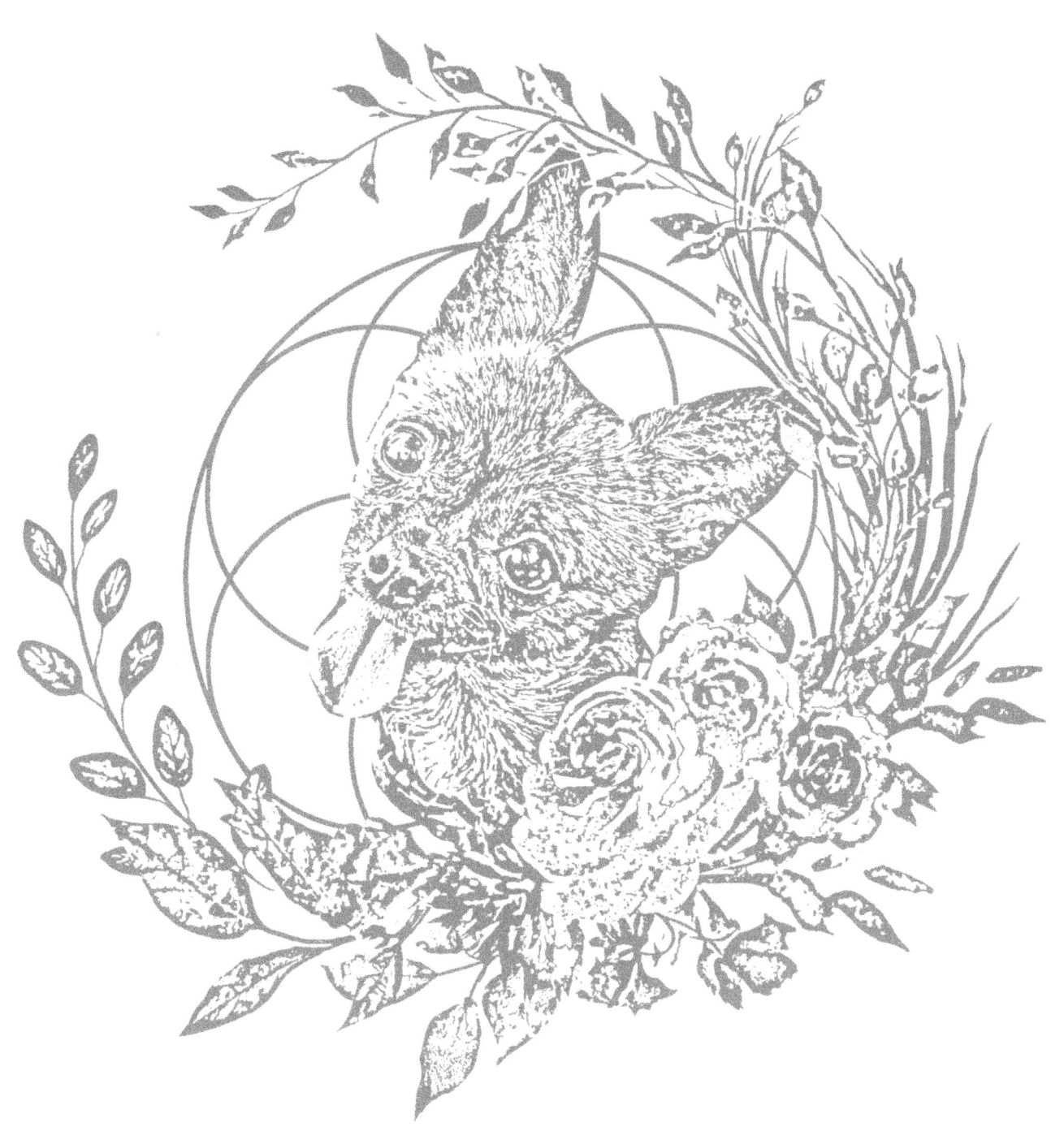

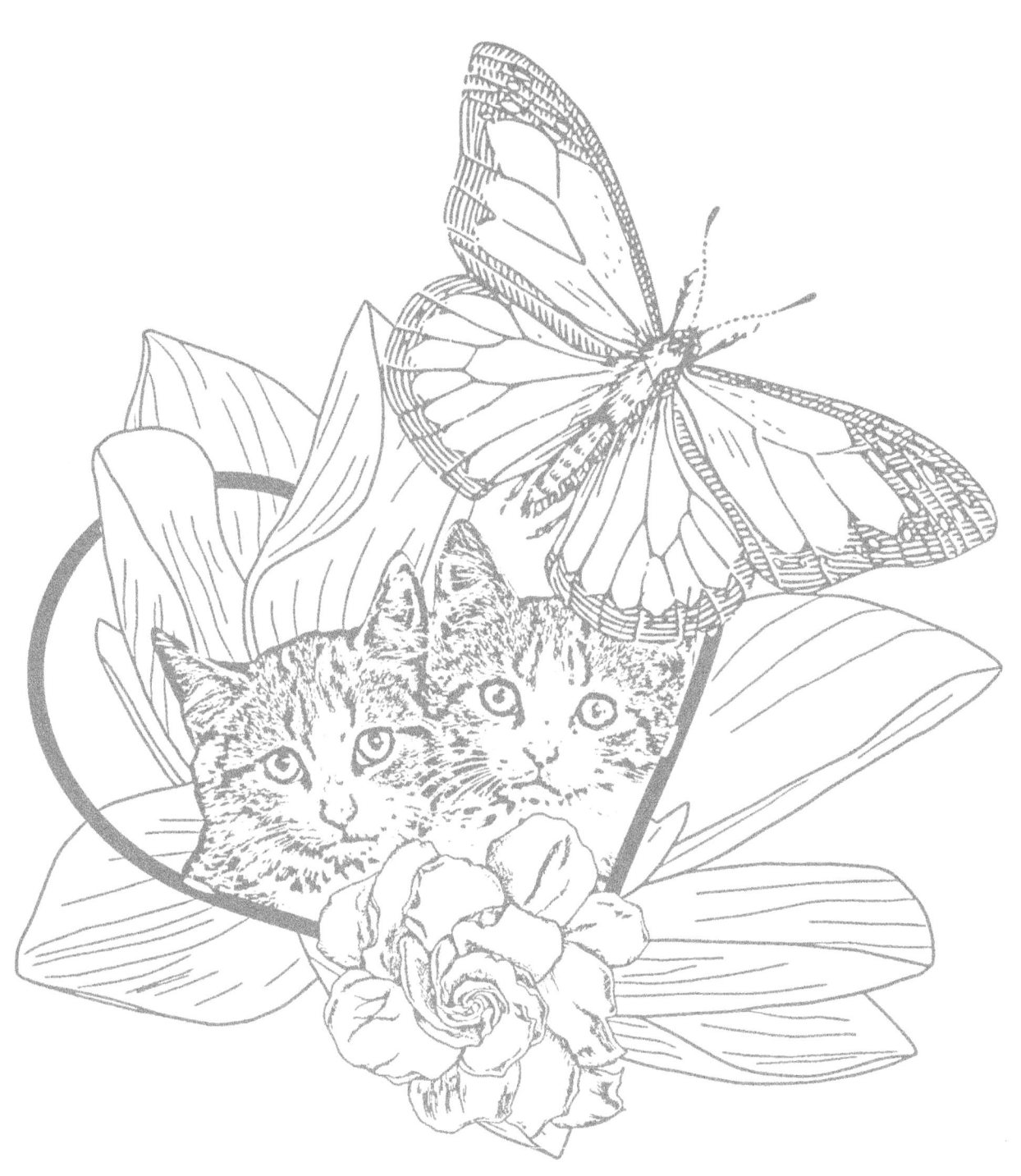

www.ingramcontent.com/pod-product-compliance
Lightning Source LLC
Chambersburg PA
CBHW041922180526
45172CB00013B/1362